GUSTON MORANDI SCULLY

PHILIP GUSTON

GIORGIO MORANDI

SEAN SCULLY

CURATED BY SUKANYA RAJARATNAM

MNUCHIN GALLERY

In 2016, Mnuchin Gallery hosted *The Eighties*, the first exhibition to revisit the revolutionary decade that launched Sean Scully's career. Two years later, the exhibition *Wall of Light* showcased works from the artist's eponymous and pivotal series. In developing this third collaboration from an ongoing conversation with Scully, we sought to cultivate a deeper understanding of his work through a dialogue with two artists who have impacted his conception of art: Giorgio Morandi and Philip Guston.

At first glance, Guston, Morandi, and Scully may seem an unlikely pairing. However, while they have distinct pictorial languages, they each address the anxiety of vision through an engagement with geometry. *Guston/Morandi/Scully* aims to establish a triangular dialogue that highlights how, through the repetitious exploration of their subjects, these artists question the nature of sight and the border between the real and the perceived, or representation and abstraction.

As we express our gratitude, we are first and foremost indebted to Sean Scully, for sharing both his insights and his art. We also thank Michellé Hoban, Faye Fleming, and the team at the Scully Studio for generously sharing their time and resources with us. Our sincere appreciation goes to Phong Bui for his profoundly illuminating text. To David Zaza and Logan Myers of McCall Associates, thank you for your guidance on this inspired catalogue design. Finally, at Mnuchin Gallery, we would like to acknowledge our colleagues Kelly Jost Gardiner, David McClelland, Arrow Mueller, Zoe Weinstein, Shandale Winston, and Lisa Zemann for their efforts in realizing this exhibition and catalogue.

ROBERT MNUCHIN SUKANYA RAJARATNAM MICHAEL MCGINNIS

THE GEOMETRY OF ANXIETY: GUSTON/MORANDI/SCULLY

PHONG H. BUI

WORKS

EXHIBITION CHECKLIST

THE GEOMETRY OF ANXIETY: GUSTON/MORANDI/SCULLY

PHONG H. BUI

"Anxiety is the dizziness of freedom"
—Soren Kierkegaard[1]

"To banish imperfection is to destroy expression, to check exertion, to paralyze vitality."
—John Ruskin[2]

"Speed now illuminates reality whereas light once gave objects of the world their shapes," wrote the French philosopher Paul Virilio.[3] As technology continues to thrive, and to exploit our addiction to instantaneous comfort, feeding us endless flows of algorithmically curated information, the inter-relations between continuity and change seem to have evolved more in the last few decades than in all of our distant past. Although science and technology have made leaps and bounds in terms of progress, the same cannot be said of the arts and humanities, for the former relies on efficiency and speed while the latter permeates our beings through endurance and slowness of contempla-tion. It's in relation to this contemplative slowness that I wish to discuss the subtle similarities and nuanced differences between the paintings of Giorgio Morandi, Philip Guston, and Sean Scully, as well as how they each possess distinct qualities with regard to their senses of self-doubt, anxiety, and imperfection.

It is in relation to the profound influence Paul Cézanne had on modern art that we must see the early evolution of Pablo Picasso, especially between 1897 and 1906, during which time the young artist's work underwent many stylistic changes. Picasso's discovery of Cézanne at the Salon d'Automne's retrospective in 1907 constitutes a singular epiphany that forever changed the

direction of his art. From that time forward, the tension between the autonomy of objectivity and the enchainment of subjectivity would remain a condition of perpetual struggle until his death in 1973. That is to say, in spite of his fluid ability to digest various perspectives, Picasso's overt emotional states, revealed especially in the dramatic shift from the Blue Period (1901–1904) to the Rose Period (1904–1906), were stressed by the young Spaniard's search for himself in his newly adopted home, Paris. Picasso must have felt an urgent need to create a style that would provide an objective framework of stability. He, like Henri Matisse and Georges Braque, among others, recognized Cézanne's full surrender to a painting process of severe impersonality, akin to a religious conversion, where a strict adherence to daily routine was of the utmost importance. However, unlike Cézanne, who was committed to working from direct observation–be it a still-life, a portrait, or a landscape–Picasso was destined to co-create Cubism with Braque as a new pictorial invention, where the representation of real life and abstraction of the imagination, flatness and illusionary depth, could co-exist in an inseparable way.

In his early years, Picasso spoke of Cézanne as the great master who guided him toward Cubism as an art of pure constructiveness and strength of forms. But later, in 1935, he clarified that: "It's not what the artist does that counts, but what he is…What forces our attention is Cézanne's anxiety. That's Cézanne's lesson."[4] Picasso ultimately suggests that while Cézanne tasked himself with the daily painting of still lives as a means to free himself from anxiety, this emotion did not simply leave him. It's in fact very much alive, right below the surface of an apple, waiting to breakthrough: as D.H. Lawrence wrote, "[Cézanne's] apple, like the moon, has still an unseen side."[5] But of course, it is not solely in painting directly from nature that artists express the anxiety that underlies all existence.

In all cases, the temperament of the artist is the most essential element in the search for a true self with a natural purpose or end. Immanuel Kant explained that while the faculty or power of judgment requires "thinking the particular under the universal,"[6] it also has "the capacity to subsume under rules, that is, to distinguish whether something falls under a given rule."[7] Here I propose two unlikely exponents as Cézanne's most faithful inheritors, namely Giorgio Morandi, who identifies

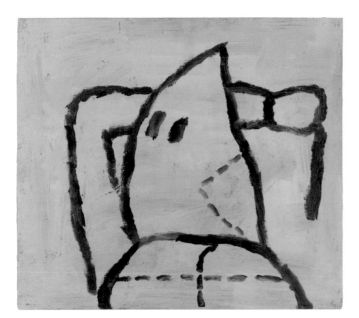

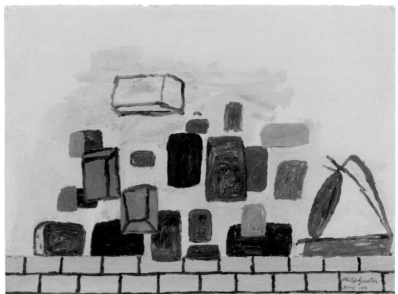

Philip Guston, *Untitled*, 1968, acrylic on panel,
18 × 20 inches (45.7 × 50.8 cm). Private Collection

Philip Guston, *Untitled (Rome)*, 1971, oil on paper. 22 × 30 inches (55.9 × 76.2 cm).
Linda and Ronald F. Daitz, New York, New York

with the master's aspiration for calmness on one side, and Alberto Giacometti, who represents the master's titanic anxiety on the other.

Both worked in abstraction—between 1918 and 1922, Morandi was making his versions of metaphysical painting, while Giacometti, between 1930 and 1935, was known for his uncanny Surrealist sculptures—before returning to work from direct observation. While it may appear at first glance, in comparing Morandi's early *Natura Morta*, 1918 and his later *Nature Morte*, that the notion of abstraction (stemming from the imagination) and language of representation (generating from life) are of extreme contrast, upon prolonged viewing we can identify at once the tranquility of space that presides in-between the painted objects, however enigmatically private or poetically familiar. I should add, the remarkably restrained use of cool and simple geometry—responsible for situating objects with acute sensitivity to the spatial proscenium of the tabletop—is adroitly calibrated in relation to the deployment of subdued colors, including umber browns and drab greens, mixed with clayed-toned whites and gradients of terra-cotta that enhance their subtle tonalities. What's equally important is that Morandi's canvases were painted frontally at eye-level. This minimized spatial depth while magnifying the monumental presence of the painted forms, that sometimes seem architecturally solid, and at other times appear as fragile as melted butter.

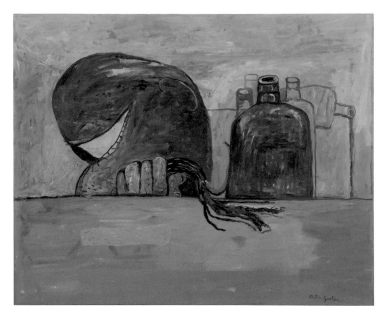

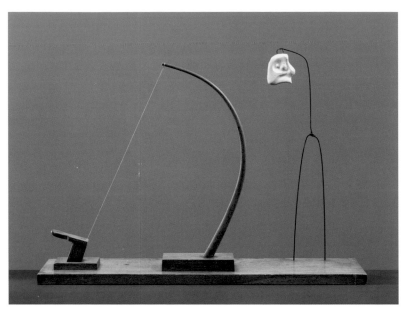

Philip Guston, *Febrile*, 1975, oil on canvas. 68 ½ x 85 ½ inches (174 × 217.2 cm).
Private Collection

Alberto Giacometti, *Fleur en danger*, 1932, wood, plaster, wire and string,
22 × 31 × 8 inches (56 × 78 × 18 cm). Kunsthaus Zurich, Alberto Giacometti-Stiftung

In *Fleur en danger*, 1932, Giacometti presents the interplay of two conflicting forces—tenderness in the flower (hung in a thin wire armature on the left) and violence, with a taut string from the bow's neck that threatens to release at any moment. An unmistakable tension fills the negative space and gradually transforms itself into existential angst. Giacometti evoked a similar anxiety in his paintings, be they still life, portraiture, cityscape, or landscape. For however conscious the artist was of his field of vision, in the end, his paintings often represented a desperate attempt to grasp the fragility of an elusive image. The question remains, if Morandi and Giacometti share a similar geometry of anxiety, despite their dissimilar approach in pictorial language, then why is Giacometti's representation excluded in this exhibition? The answer is fairly simple: As a painter, Giacometti expressed his existential concern for the human condition through the act of drawing—or rather an action of demarcating, etching and re-etching, back and forth, with endless lines at the expense of oil paint as a mere pretext for erasure. Here, the appearance and disappearance of things would often become virtually undecipherable.

In the works of Morandi, Guston, and Scully, form is mediated through the sensual manipulation of the body in paint rather than line. One can also argue for the distinct difference that populates both sides of the positive and negative space; All elements of organic life—such as the ordinary apple hanging on a tree, for example—expand like positive forms in space. The apple absorbs nutrients from sunlight, water, and soil in order to grow while pushing outward against the surrounding negative

space. However, once it reaches its maximal maturity and is fully ripened, the negative space will begin to push it inward towards its natural decay: eventually, as a result of earth's gravitational pull, the apple will fall off its branch, gradually deteriorate into the earth, and become nothing more.

For Morandi, as for Guston and Scully, drawing serves as a skeleton that implies each line is a mere indication of this positive/negative boundary. Morandi may declare one space on the left is equally as important as the one on the right, as he draws on a somewhat slow pace, without hesitation at any time, without erasure, without revision. On the contrary, in the case of Giacometti, the conjectural contingencies of form cannot be rested on the artist's impossible aim to capture an image over time, from which moment either the subject or the artist is always in constant flux. Hence, his crisis of doubting what can be seen becomes mired in his anxious desire to confront the powerful force of the void. Even if one could separate the context from the content by a line, emptiness is not context, and neither is a line. The question to then ask is: By the mere nonexistence of being, is a painting the byproduct of the invisible, made visible, in the flash of a second before its disappearance?

Piet Mondrian, having brought Cubism to its logical conclusion through the grid, with its vertical and horizontal lines of unequal thickness, reminds us, again and again, that he has expanded the space of painting beyond the confinement of its usual square format. Indeed, he essentially eliminated the concept of the frame. It's critical to point out that Guston was inspired by Mondrian's early plus/minus pictures, namely his *Pier and Ocean* series (1912–1914), where the master forged his approach to abstraction through Cubism by constructing his geometries within an oval shape. The desire to contain the aura of the image within the frame is similarly applied in the cases of Morandi, and Scully, even when it appears more visible with the former than the latter, which I will address later in this essay.

Both otherwise appealed to classicism's stable field of vision, where, as Meyer Shapiro explained, "the non-mimetic elements of the image-sign and their role in constituting the sign…certain of them, like the frame, are historically developed, highly variable forms, yet obviously conventional, they do not have to be learned for the image to be understood; they may even acquire a semantic value."[8] At this point, one would therefore argue that without Mondrian's elimination of the frame,

it would be impossible for Pollock's late drip paintings to be read as the precursors of Happenings and Performance Art. Even with Mondrian, in his ambitious reduction of painting's pictorial vocabulary to its elemental and irreducible means, on close inspection, one can see that these straight lines have many times been moved back and forth, painted and re-painted repeatedly as an active resistance to the dictation of logic. The active resistance to a logical framework is visibly shown in Guston's personal commitment to painting as an ongoing process of reciprocal responses between the artist and his surroundings, or what Robert Storr called "a self-contained and constantly evolving 'here and now.'"[9]

This active resistance also perceives, as Guston himself observed, "[p]ainting (as) the clock that sees both ends of the street as the end of the world."[10] It applies to Morandi and Scully in their mediations on self-doubt and anxiety differently, for they co-exist as an urgent condition of *negative capability*,[11] once submitted to unconditional self-acceptance, they're at the helm of constant regeneration. At times this appears with minute permutations (as seen in Morandi's timeless depictions of the bottles in his *Natura Morta*), at others with dramatic shifts, as revealed in both Guston's and Scully's own versions of active resistance.

One can detect a shared affinity between Guston and Scully, especially in their aptitude for adapting in the act of painting—for whatever measure of self-awareness materializes in the work, it is enhanced by the memory of previous events, either expressed as an episodic whole or in fragments. Be it subject matter in response to a social, political evaluation in their mutual expectations of themself as artists and members of the general public; or changes in the physical scale of the work, the materials, or the representation of the made-image through imagination, fed by memory or abstraction. In other words, if one were to confer the intense richness and complexities that had occurred in their lives, both being informed and haunted by their memories, one would think there's no choice but to surrender completely to the quest for the absolute, which requires vulnerability and resolute self-determination. Guston and Scully have both, in fact, made such confessions. Guston wrote, "I got sick and tired of all that purity. I wanted to tell stories."[12] Scully, "I think my work is really quite biographical. I allow my situation to affect the temperature of the work."[13]

Giorgio Morandi, *Natura Morta*, 1918, oil on canvas,
21.7 × 25.6 inches (65 × 55 cm). Jucker Collection, Museo
d'Arte Contemporanea, Palazzo Reale, Milan

Again, the desire to tell stories and the issue of being haunted by memory, feels so subtle in Morandi's case, where his bottles and containers are presented with an extremely cautious articulation of negative space. One feels as though Morandi's compositions appear to him as an unending confrontation between contingency and abstraction, between the particular and the general. Here, Morandi, like Giacometti, is not at all interested in any vision of spiritual utopia based on ideal aesthetic harmony, for he perceives working from direct observation is a spiritual practice that maintains a concrete relationship to life itself. However, as metaphysical painting's deployment of incongruous imagery generates disquieting effects on the viewer, it provided a pathway for Surrealism to unlock the power of the unconscious mind. Morandi never abandoned this narrative, which has always been consistently and intimately kept within the proscenium of his field of vision.

It is within this framework that Guston and Scully also seem to wholeheartedly accept the paradoxes of life, driven by self-doubt and anxiety in their search for certainty and calmness. Indeed, Guston found solace in Piero della Francesca's small masterpiece, *Flagellation*, c. 1450–60, a subject of serious inquiry and mystery (the three figures in the right foreground can be seen as plotting a contemporary political assassination in their conspiracy against Christ, who is being flagellated in the left background). On various occasions, Guston would redeploy this image of a figure with a whip, often depicting Klansman and himself as a blurred-identity in crisis—the whipping representing a

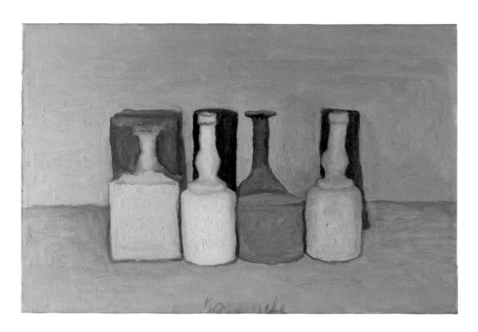

Giorgio Morandi, Natura Morta, 1956, oil on canvas. Museo Morandi, Bologna

gesture of great anxiety. Still, among Piero's primary characteristics is the undisguised avoidance of drama: painted slightly lower than the eye level, his figures maintain their own gravity of appearance, the firmness of their legs anchoring them to the ground as if it were a tabletop. As a result, his figures not only amplify the painting's monumental presence but also its sense of timeless serenity and calm. Guston's *The Mirror* (1957), can be seen as the metaphysical equivalent to this image, through both its appearance and disappearance, it's seen and unseen perspectives.

Intensified by the nature of his restless spirit, Scully's early exploration of the grid was part of a personal metamorphosis that worked through the influences of Picasso, Mondrian, Ad Reinhardt, Frank Stella, and even Kenneth Noland. For more than a decade, from the seminal painting *Morocco* (1969) to *Catherine* (1981), Scully exhausted all possible experimentation known to this exceptional and singular pursuit. Stripes in all matter of applications, with or without the grid, were at times, closeup, frontal, and flat; at others, they were painted with complex layers in all directions—vertical, horizontal, and diagonal where both spatial recess and repetition of rhythm are maximized in a most productive and frenetic pace.

Since the arrival of Scully's now-landmark painting of 1981, *Backs and Fronts*, he has made it his mission to expand and extend the possibilities of the grid, in its countless forms and in its relation to the concept of the frame and boundary. His works are informed by his personal sense of

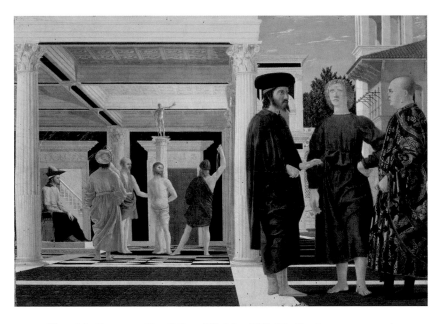

Piero della Francesca, *Flagellation of Christ*, c. 1450–60, oil on tempera on panel,
23 × 32 ⅛ inches (58.4 × 81.5 cm). Galleria Nazionale delle Marche, Urbino

spatial discrepancy, presented in every unexpected proposal of form and content, every possible unity of pictorial friction. As his paintings have grown larger in size, so have his stripes. In turn, they have demanded more conventional formats to regulate and individuate the complexities of imagery and scale, in varying degrees of temperature. This intensity is essential to the prevailing mood of each painting and is perhaps the characteristic which has proven most consistent from the outset of his career as a young painter.

Lastly, it would be impossible to contemplate these paintings by Morandi, Guston, and Scully without mentioning the alchemy of their material practices; how each applies oil pigment onto the surface in relation to his personal sense of touch; for everything spiritual, and intellectual, can also be read and felt through sensual manipulation of the material. For example, in looking at the six Morandi *Natura Morta* paintings that spanned thirteen years in the making (1946-1959), one observes the consistency of his color palette, comprised largely of muted colors, painted in a buttery wet-on-wet application of well-measured and visible brushstrokes. Morandi's methodical approach only accentuates the immense presence of the void as an operating force—a criterion from which he mediates the proximity or distance of space between his bottles. As he famously responded when asked why he painted bottles most of his life: "I don't paint the bottles. I paint the space between them."[14]

In the case of Guston, paintings such as *Branch*, (page 29), again *The Mirror* (page 23), and *The Day* (page 61), reveal his gradual shift from what was known as the tail end of his so-called Abstract Impressionist pictures of the 1950s, to the "dark pictures" of mid-1960s.[15] Having absorbed Zen Buddhism's practice of equanimity and acceptance through his close friendship with John Cage; the free-flowing, slow-evolving sound and recurring asymmetric patterns of Morton Feldman; Mondrian's plus/minus; Kierkegaardian either/or, whatness/whereness, image-as-field/field-as-image, and everything else in-between: Guston's treatment of forms grew increasingly larger, in harmony with his palette of blood-red, pink, murky-green, and pale-blue, amid seas of gray and white. His compositions became more centralized as they honed in on the space from which he "saw the grid-in-flux [as a] metaphoric vehicle for unrelenting doubt and anxiety."[16]

For Scully, his most recent paintings have been tempered by his stack sculptures—as evidenced by *Robe Diptych 1* (page 58–59), *Air (Maquette)* (page 27), and *Mud Sky Diptych* (page 39), for example. They offer up architectonic, rectilinear swatches, that stretch to their edges vertically and horizontally with a monumental presence. Yet, curiously, due to the rich spectrum of his palette, his paintings consist of unnamable colors. For whatever the color—be it a layer of yellow ochre painted over ivory back while the paint is still tacky—the second coat picks up the first, and as a result, produces a rustic patina on the surface. These unnamable colors keep us spell-bound by their majestic familiarity—as though each of us is entitled to invent a name for every color: say almond beige, acorn tan, toasted chestnut brown, earthy russet, or flamenco red to Grecian green, clay gray, brownstone gray, or moonlight white, and silver bells white. While Scully's paintings intimately articulate the forces of monumentality, one could say Morandi's forms are monumentally intimate. Guston then provides a middle-way, a perfect paradox that exists within and beyond the opposites, between being and non-being, between form and emptiness, between free will and determinism.

Here, I conclude with a story: Sometime in late November 2008, the most subtle and hermetic artist Bob (Robert) Ryman, an important friend of Scully and mine, declined to visit the Morandi retrospective at the Met. He had seen enough of Morandi's painting as a guard at MoMA (1953 to

1960), he said. I still vividly remember saying to Bob, "But of all the artists we both know, you are the one who would be most sympathetic to Morandi's monastic sensibility." His response: "Morandi's painting makes me very anxious."[17]

Notes

1. Reidar, Thomte, trans., Kierkegarrd, Soren, *The Concept of Anxiety: A Simple Psychologically Orienting Deliberation on the Dogmatic Issue of Hereditary Sin* (Princeton University Press, 1998), p. 162

2. Ruskin, John, *The Stones of Venice* (1854), chapter 6, 2nd vol., p. 14

3. Virilio, Paul, Richard, Bertrand, *The Administration of Fear* (MIT Press, 2012), p. 41

4. Zervos, Christian, *Conversation avec Picasso*, in Cahiers d'art, 10:10 (1935), pp. 173–38; trans. in Chipp B. Herchel, ed., *Theories of Modern Art* (Berkeley: University of California Press, 1968), pp. 266–73, see p. 272

5. Lawrence, D.H. *Art and Morality* (The Calendar of Modern Letters, November 1925), pp. 175–76

6. Ginsborg, Hannah, Kukla, Rebacca, ed. *Thinking the Particular as Contained under the Universal, Aesthetics and Cognition in Kant's Critical Philosophy* (Cambridge University Press 2006), p. 35

7. Ibid, p. 42

8. Schapiro, Meyer, *On Some Problems in the Semiotics of Visual Arts: Field and Vehicle in Image-Signs, Theory and Philosophy of Art: Style, Artists, and Society*, Selected Papers (George Braziller, New York), p. 1

9. Storr, Robert, *Guston* (Abbeville Modern Master, 1986), p. 36

10. Guston, Philip, *Statement* (It Is 1, Spring 1958), p. 44

11. Keats, John, From letter from the poet to his two brother, George and Thomas on December, 22, 1817) to defend a writer's ability," to accept "uncertainties, mysteries, doubts, without any irritable reaching after fact and reason."

12. From a conversation with the poet, art critic Bill Berkson in 1970

13. Carrier, David *Sean Scully* (Thames and Hudson, 2004), p. 14

14. From a conversation between the author and Mercedes Matter, September 1986

15. A termed coined by Louis Finkelstein, *New Look: Abstract-Impressionism* (Art News, LV, No.1, March 1956), p. 36

16. Storr, Robert, *A Life Spent Painting* (Laurence King Publishing, London 2020), p. 54

17. Bui, Phong, *In Conversation with Julian Schnabel* (The Brooklyn Rail, September 2017), p. 22

WORKS

SEAN SCULLY
WALL WEST SIDE
2021

OIL ON LINEN

75 × 85 INCHES

(190.5 × 215.9 CM)

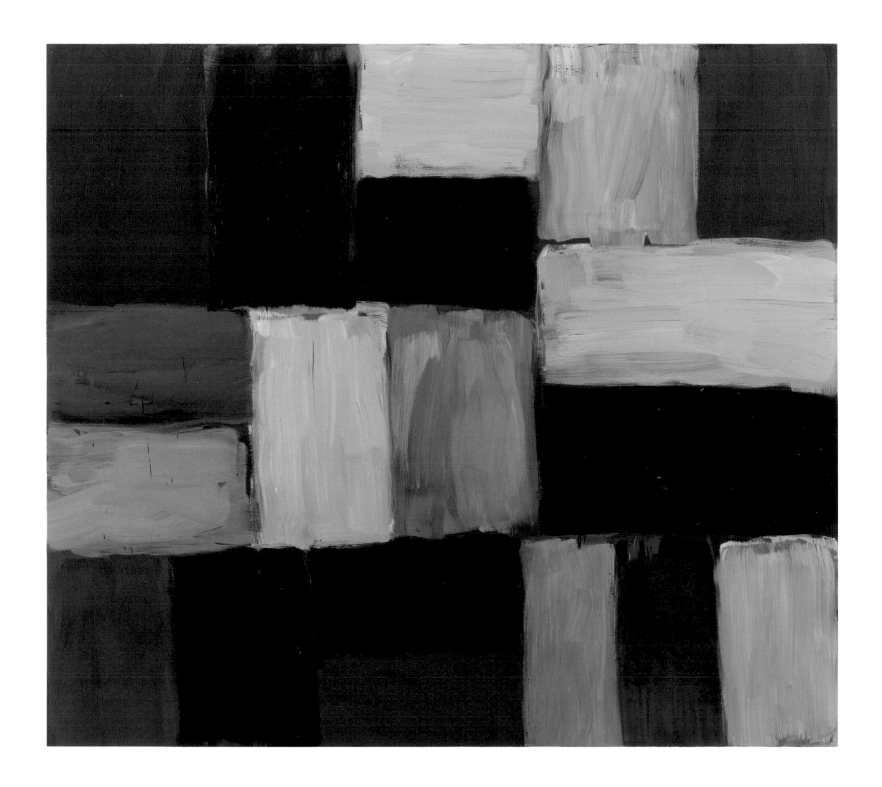

PHILIP GUSTON
THE MIRROR
1957

OIL ON CANVAS

68 × 60 ½ INCHES

(172.7 × 153.7 CM)

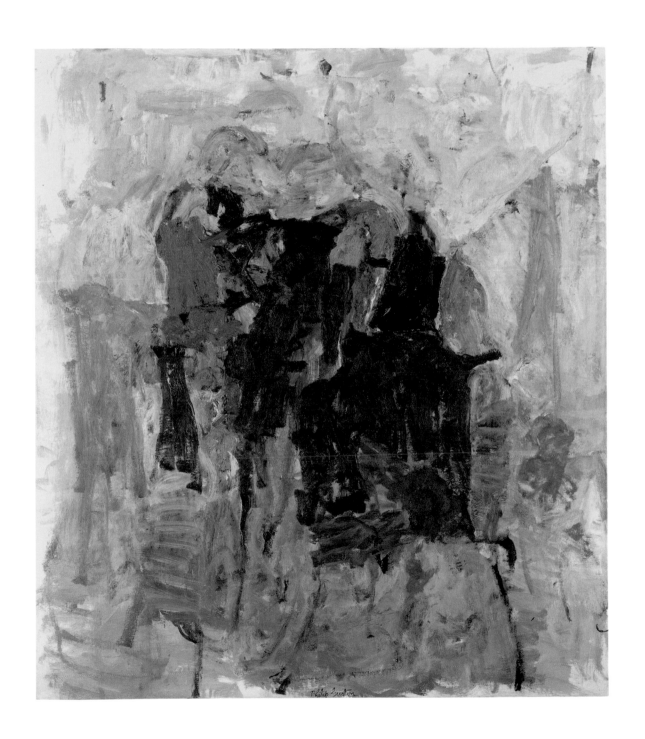

GIORGIO MORANDI

FIORI

1947

OIL ON CANVAS

11 ½ × 8 ½ INCHES

(29.2 × 21.6 CM)

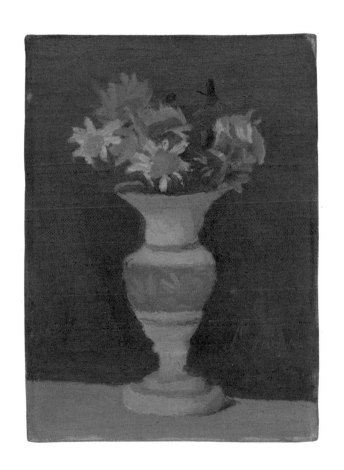

SEAN SCULLY
AIR (MAQUETTE)
2019

RECINTO, MARBLE, AND CANTERA

7 7/8 × 7 7/8 × 11 13/16 INCHES

(20 × 20 × 30 CM)

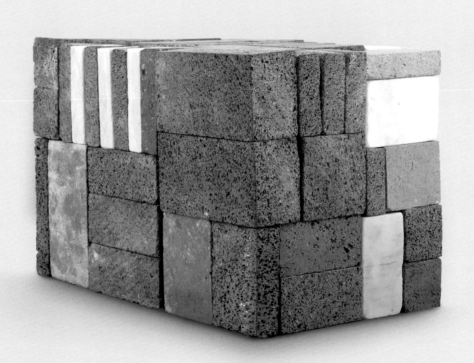

PHILIP GUSTON

BRANCH

1956–58

OIL ON CANVAS

71 ⅞ × 76 INCHES

(182.6 × 193 CM)

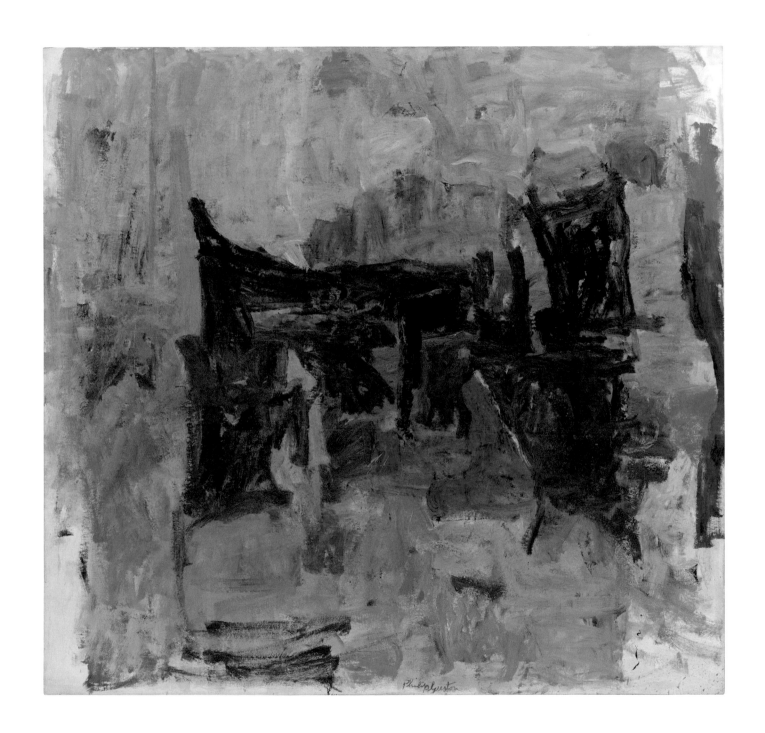

SEAN SCULLY
WALL FEZ
2021
OIL ON LINEN
75 × 85 INCHES
(190.5 × 215.9 CM)

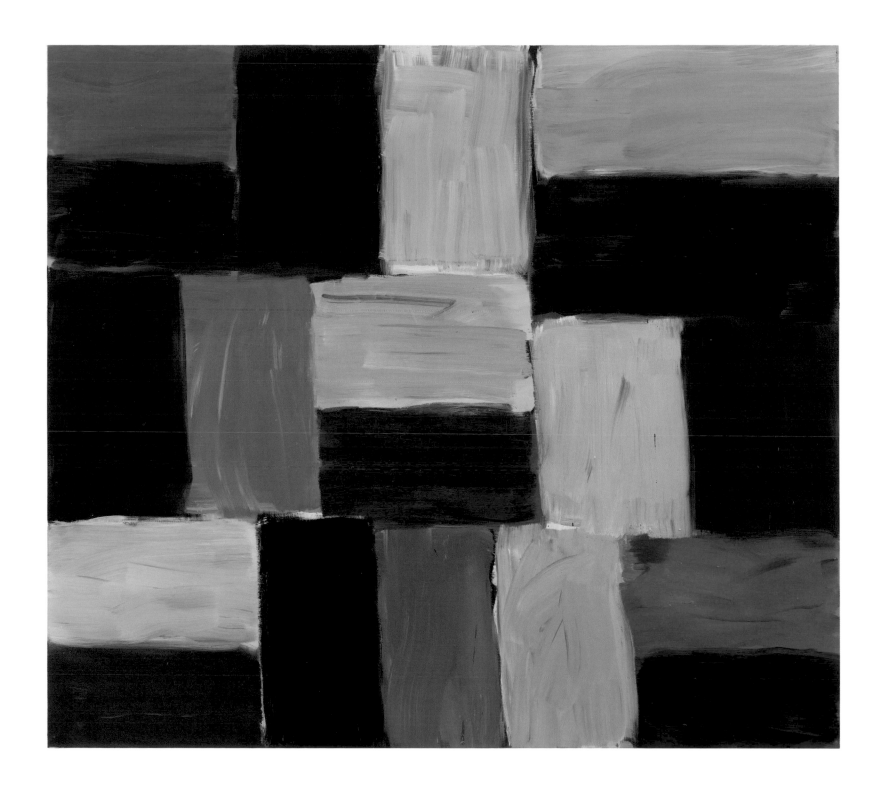

PHILIP GUSTON
PATH II
1960

OIL ON CANVAS

62 ½ × 71 ½ INCHES

(158.8 × 181.6 CM)

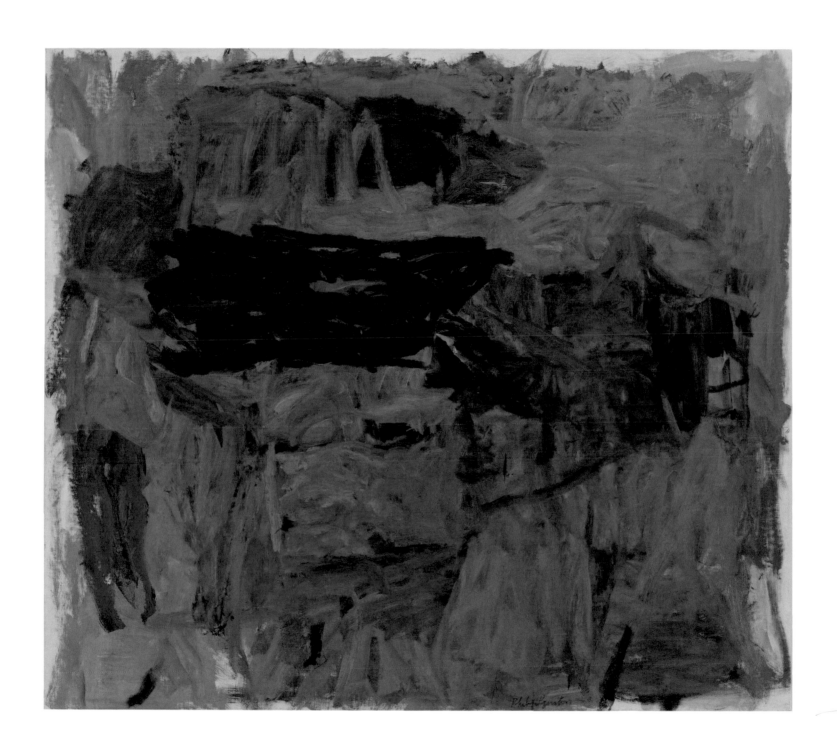

GIORGIO MORANDI
NATURA MORTA

1946

OIL ON CANVAS

10 ¼ × 16 ¾ INCHES

(26 × 42.5 CM)

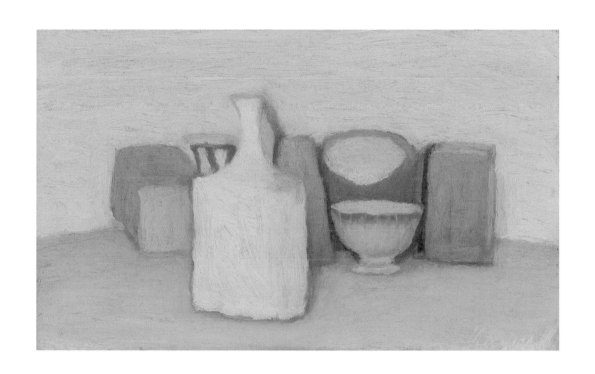

SEAN SCULLY

AUGUSTINE

2021

OIL ON LINEN

42 × 48 INCHES

(106.7 × 121.9 CM)

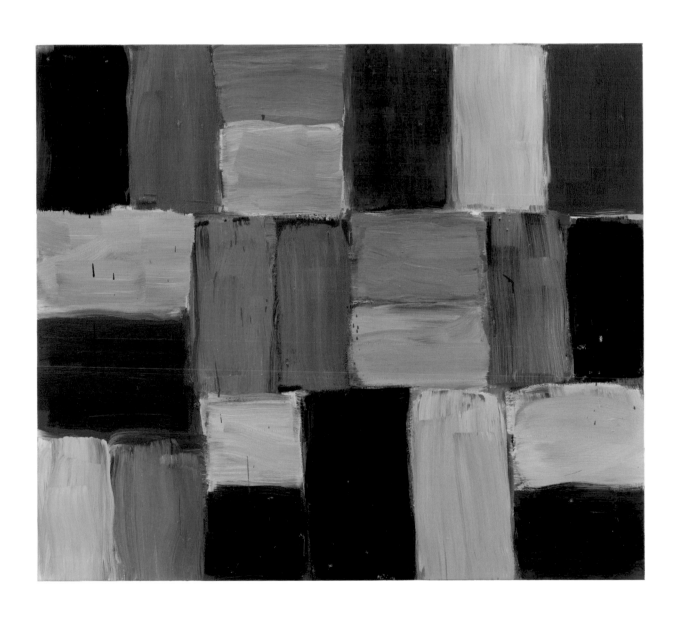

SEAN SCULLY
MUD SKY DIPTYCH

2019

OIL ON ALUMINUM

51 × 55 INCHES

(129.5 × 139.7 CM)

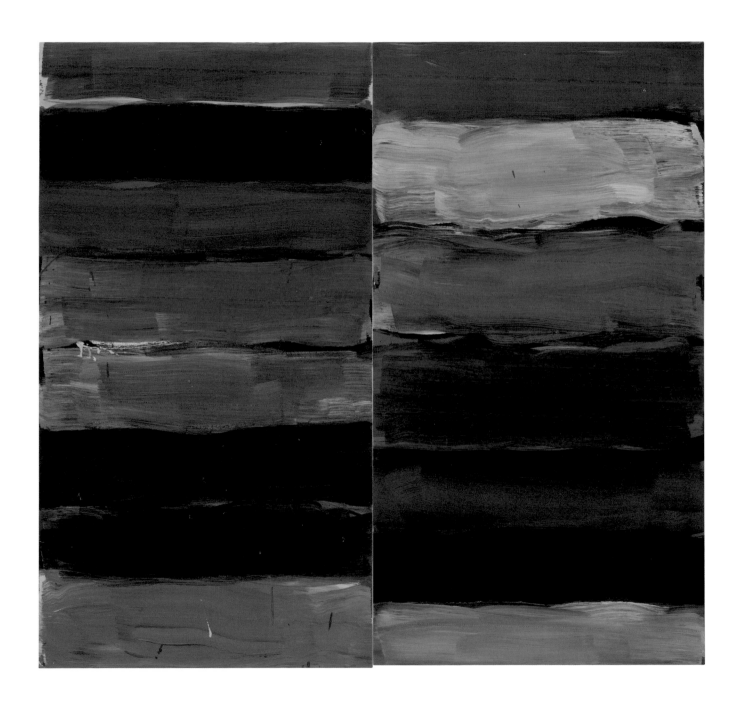

GIORGIO MORANDI
NATURA MORTA

1948

OIL ON CANVAS

8 ¼ × 12 ⅞ INCHES

(20.6 × 32.7 CM)

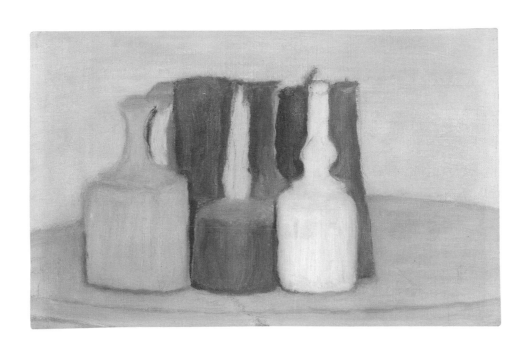

SEAN SCULLY
WALL LANDLINE MAROON
2022

OIL ON ALUMINUM

85 × 75 INCHES

(215.9 × 190.5 CM)

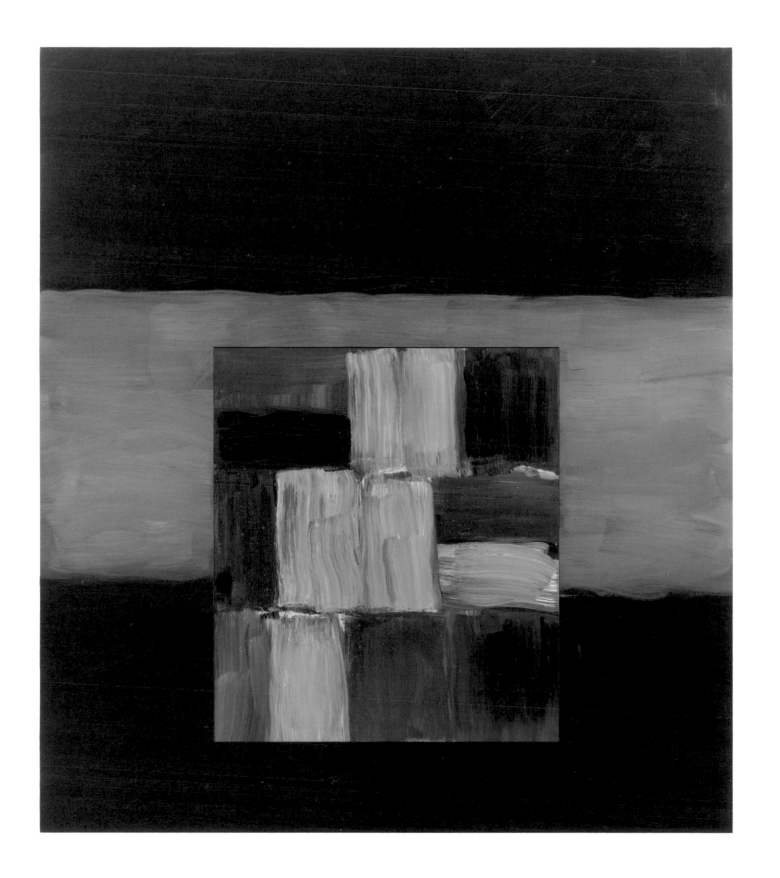

SEAN SCULLY

SMALL CUBED 2

2021

HANDCRAFTED STONE BLOCKS

12 ⅝ × 10 ⅝ × 17 ¾ INCHES

(32 × 27 × 45 CM)

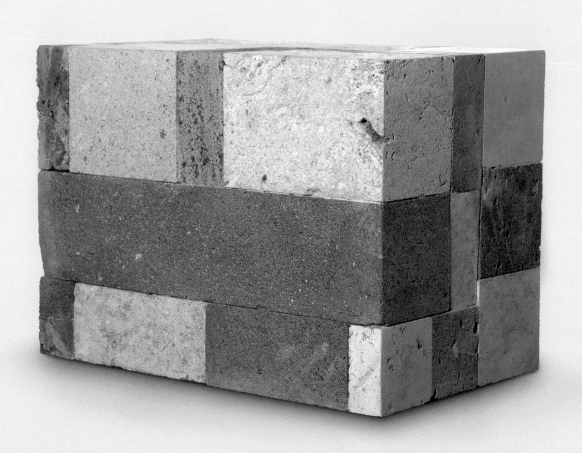

GIORGIO MORANDI

NATURA MORTA

1959

OIL ON CANVAS

10 ⅛ × 16 INCHES

(25.7 × 40.6 CM)

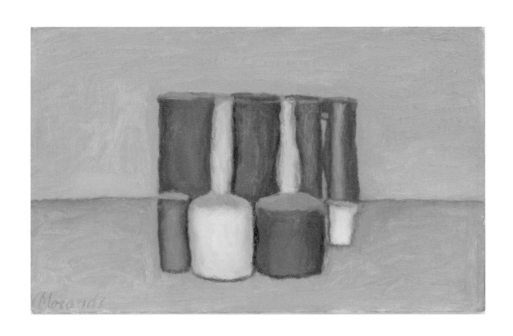

SEAN SCULLY

SMALL CUBED 9

2021

HANDCRAFTED STONE BLOCKS

19 ⅝ × 19 ⅝ × 17 ¾ INCHES

(50 × 50 × 45 CM)

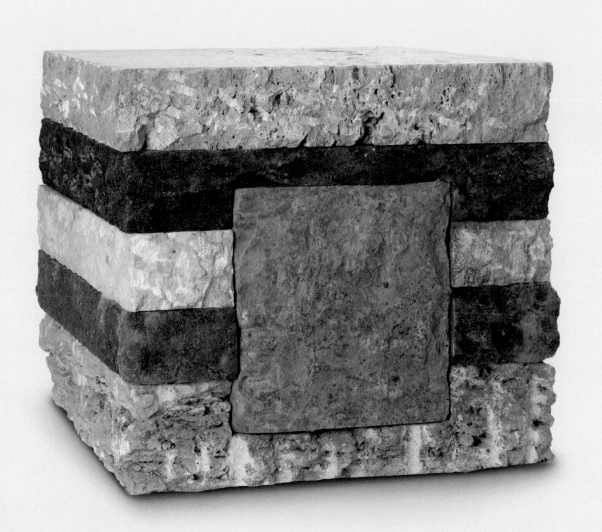

SEAN SCULLY
WALL LANDLINE HIGH ATLAS

2022

OIL ON ALUMINUM

85 × 75 INCHES

(215.9 × 190.5 CM)

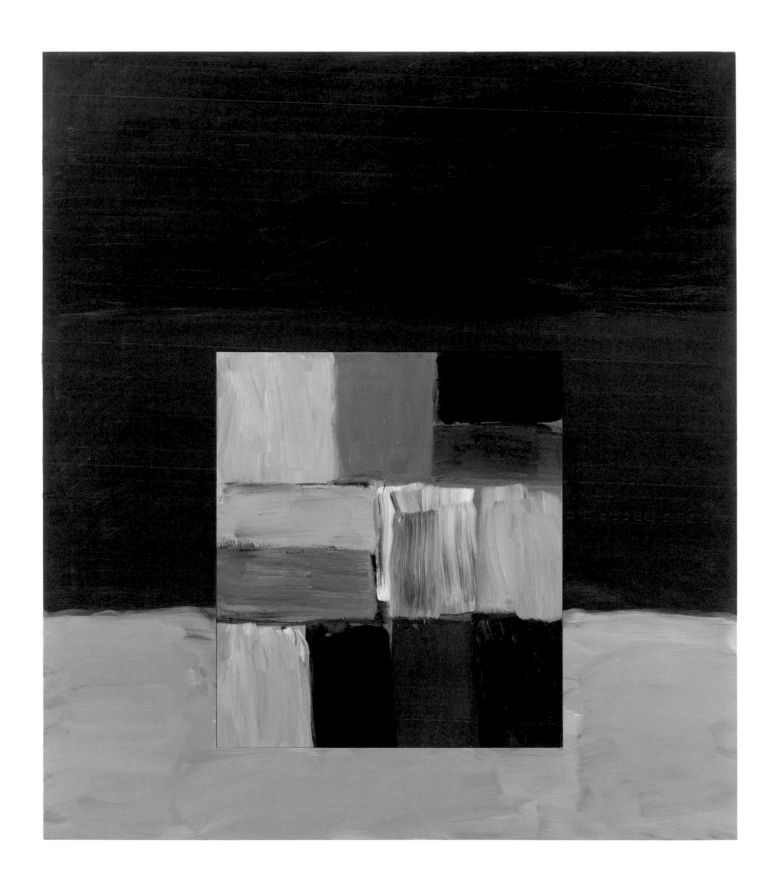

SEAN SCULLY

SMALL CUBED 4

2021

HANDCRAFTED STONE BLOCKS

23 ⅝ × 9 ⅞ × 9 ⅞ INCHES

(60 × 25 × 25 CM)

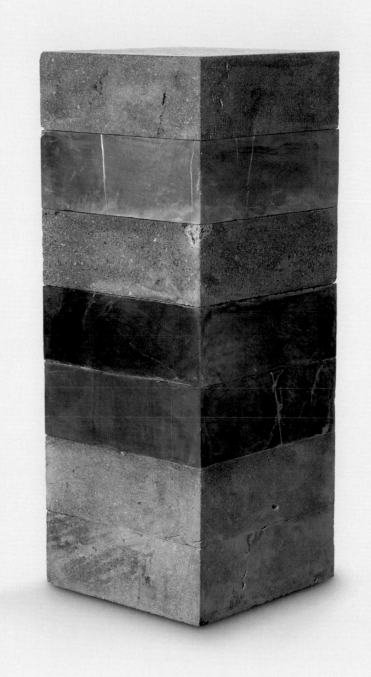

SEAN SCULLY
SMALL CUBED 7

2021

HANDCRAFTED STONE BLOCKS

23 ⅝ × 11 ¹³⁄₁₆ × 11 ¹³⁄₁₆ INCHES

(60 × 30 × 30 CM)

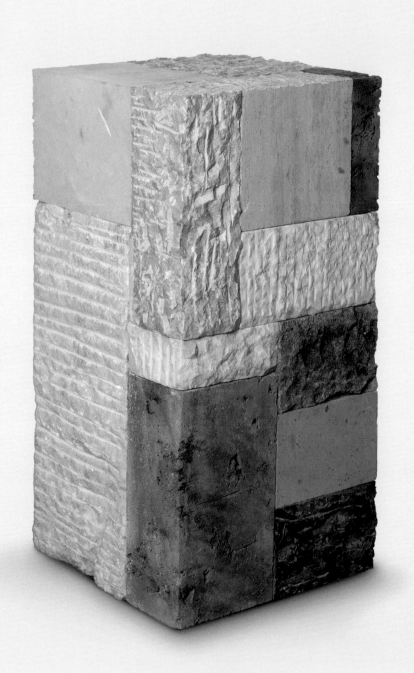

SEAN SCULLY

JUDE

2022

OIL ON LINEN

63 × 63 INCHES

(160 × 160 CM)

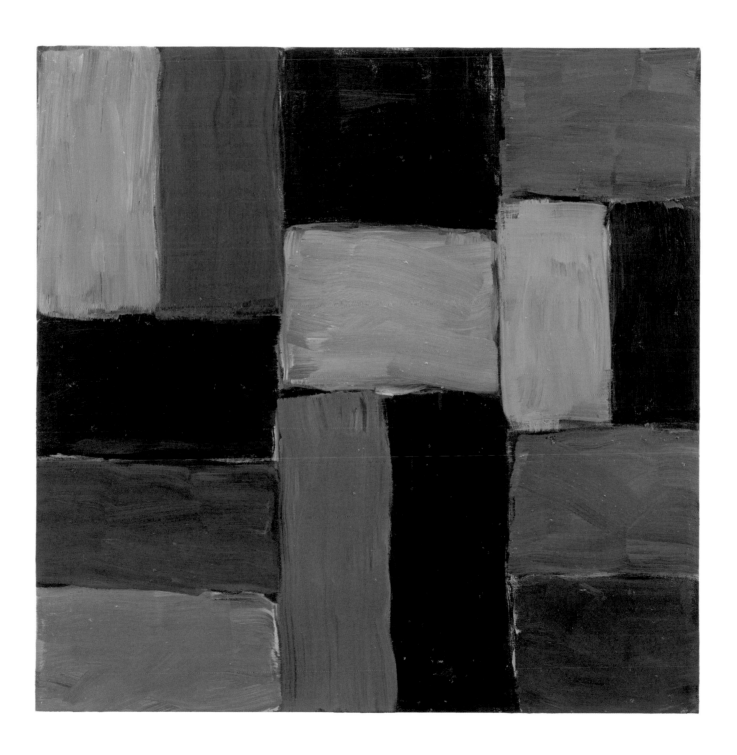

SEAN SCULLY
ROBE DIPTYCH 1
2019

OIL ON ALUMINUM

85 × 150 INCHES

(215.9 × 381 CM)

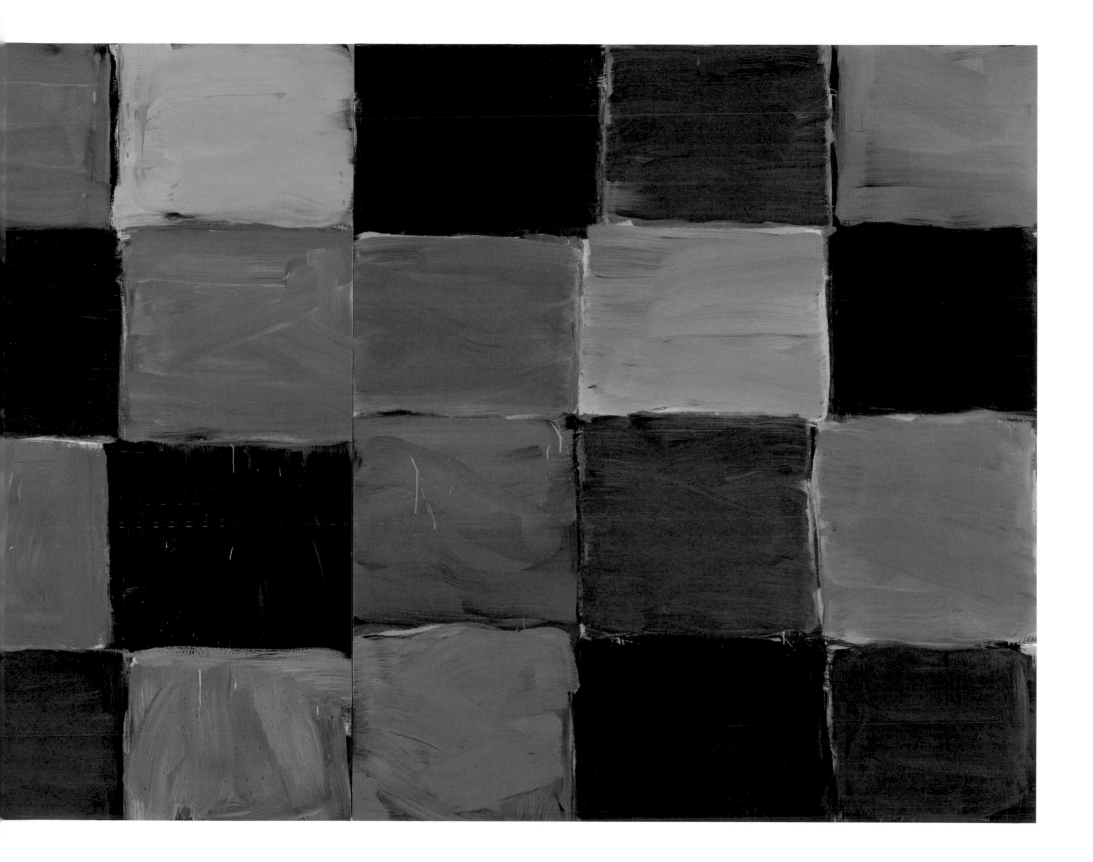

PHILIP GUSTON
THE DAY
1964

OIL ON CANVAS

77 × 80 INCHES

(195.5 × 203.2 CM)

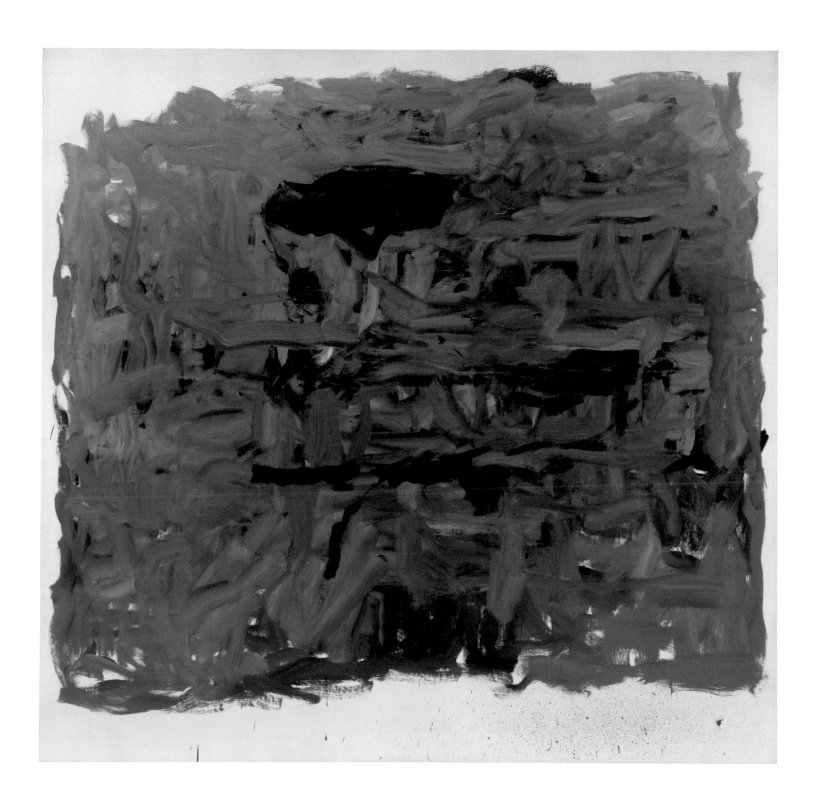

GIORGIO MORANDI

NATURA MORTA

1946

OIL ON CANVAS

9 $\frac{4}{5}$ × 18 ¼ INCHES

(25 × 46.4 CM)

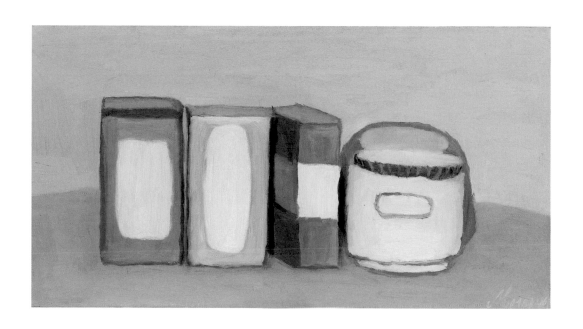

GIORGIO MORANDI
NATURA MORTA
1953

OIL ON CANVAS

14 ½ × 15 INCHES

(37 × 38.5 CM)

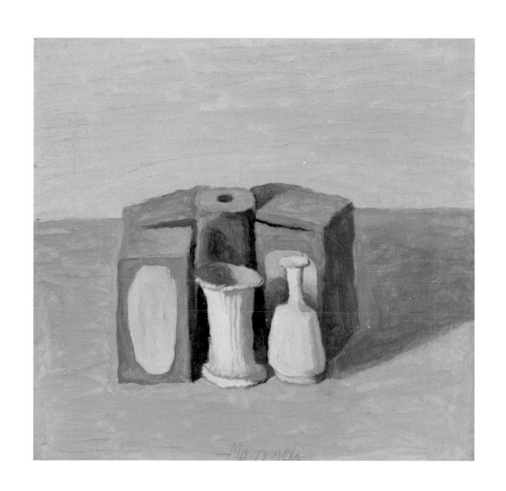

SEAN SCULLY
WALL BLOOM
2022

OIL ON LINEN

28 × 30 INCHES

(71.1 × 76.2 CM)

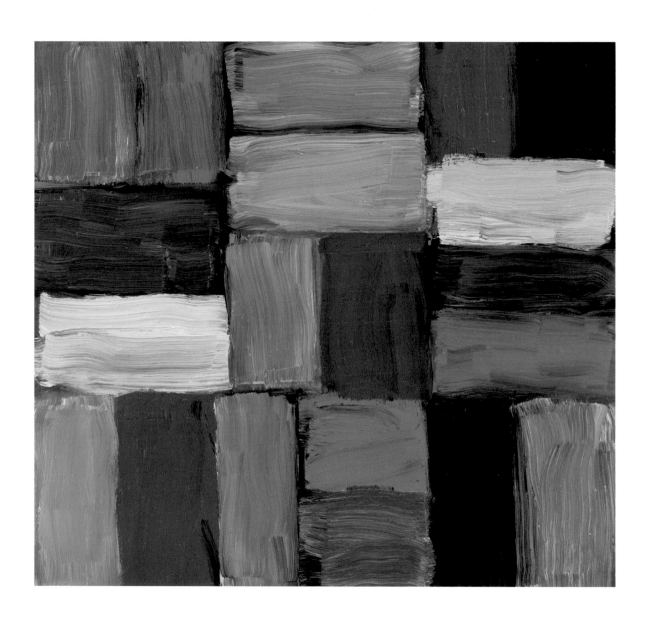

EXHIBITION CHECKLIST

SEAN SCULLY

WALL WEST SIDE

2021

OIL ON LINEN

75 × 85 INCHES

(190.5 × 215.9 CM)

PAGE 21

GIORGIO MORANDI

FIORI

1947

OIL ON CANVAS

11 ½ × 8 ½ INCHES

(29.2 × 21.6 CM)

PRIVATE COLLECTION COURTESY DAVID ZWIRNER

PAGE 25

PHILIP GUSTON

BRANCH

1956–58

OIL ON CANVAS

71 ⅞ × 76 INCHES

(182.6 × 193 CM)

PRIVATE COLLECTION

PAGE 29

PHILIP GUSTON

THE MIRROR

1957

OIL ON CANVAS

68 × 60 ½ INCHES

(172.7 × 153.7 CM)

PRIVATE COLLECTION

PAGE 23

SEAN SCULLY

AIR (MAQUETTE)

2019

RECINTO, MARBLE, AND CANTERA

7 ⅞ × 7 ⅞ × 11 ¹³⁄₁₆ INCHES

(20 × 20 × 30 CM)

PAGE 27

SEAN SCULLY

WALL FEZ

2021

OIL ON LINEN

75 × 85 INCHES

(190.5 × 215.9 CM)

PAGE 31

PHILIP GUSTON

PATH II

1960

OIL ON CANVAS

62 ½ × 71 ½ INCHES

(158.8 × 181.6 CM)

PRIVATE COLLECTION

PAGE 33

SEAN SCULLY

MUD SKY DIPTYCH

2019

OIL ON ALUMINUM

51 × 55 INCHES

(129.5 × 139.7 CM)

PAGE 39

SEAN SCULLY

SMALL CUBED 2

2021

HANDCRAFTED STONE BLOCKS

12 ⅝ × 10 ⅝ × 17 ¾ INCHES

(32 × 27 × 45 CM)

PAGE 45

GIORGIO MORANDI

NATURA MORTA

1946

OIL ON CANVAS

10 ¼ × 16 ¾ INCHES

(26 × 42.5 CM.)

PAGE 35

GIORGIO MORANDI

NATURA MORTA

1948

OIL ON CANVAS

8 ⅛ × 12 ⅞ INCHES

(20.6 × 32.7 CM)

PAGE 41

GIORGIO MORANDI

NATURA MORTA

1959

OIL ON CANVAS

10 ⅛ × 16 INCHES

(25.7 × 40.6 CM)

PRIVATE COLLECTION COURTESY DAVID ZWIRNER

PAGE 47

SEAN SCULLY

AUGUSTINE

2021

OIL ON LINEN

42 × 48 INCHES

(106.7 × 121.9 CM)

PAGE 37

SEAN SCULLY

WALL LANDLINE MAROON

2022

OIL ON ALUMINUM

85 × 75 INCHES

(215.9 × 190.5 CM)

PAGE 43

SEAN SCULLY

SMALL CUBED 9

2021

HANDCRAFTED STONE BLOCKS

19 ⅝ × 19 ⅝ × 17 ¾ INCHES

(50 × 50 × 45 CM)

PAGE 49

SEAN SCULLY

WALL LANDLINE
HIGH ATLAS

2022

OIL ON ALUMINUM

85 × 75 INCHES

(215.9 × 190.5 CM)

PAGE 51

SEAN SCULLY

JUDE

2022

OIL ON LINEN

63 × 63 INCHES

(160 × 160 CM)

PAGE 57

GIORGIO MORANDI

NATURA MORTA

1946

OIL ON CANVAS

9 ⅘ × 18 ¼ INCHES

25 × 46.4 CM

PAGE 63

SEAN SCULLY

SMALL CUBED 4

2021

HANDCRAFTED STONE BLOCKS

23 ⅝ × 9 ⅞ × 9 ⅞ INCHES

(60 × 25 × 25 CM)

PAGE 53

SEAN SCULLY

ROBE DIPTYCH 1

2019

OIL ON ALUMINUM

85 × 150 INCHES

(215.9 × 381 CM)

PAGES 58–59

GIORGIO MORANDI

NATURA MORTA

1953

OIL ON CANVAS

14 ½ × 15 INCHES

(37 × 38.5 CM)

PAGE 65

SEAN SCULLY

SMALL CUBED 7

2021

HANDCRAFTED STONE BLOCKS

23 ⅝ × 11 ¹³⁄₁₆ × 11 ¹³⁄₁₆ INCHES

(60 × 30 × 30 CM)

PAGE 55

PHILIP GUSTON

THE DAY

1964

OIL ON CANVAS

77 × 80 INCHES

(195.5 × 203.2 CM)

PRIVATE COLLECTION

PAGE 61

SEAN SCULLY

WALL BLOOM

2022

OIL ON LINEN

28 × 30 INCHES

(71.1 × 76.2 CM)

PAGE 67

Published on the occasion of the exhibition:

PHILIP GUSTON
GIORGIO MORANDI
SEAN SCULLY

CURATED BY SUKANYA RAJARATNAM

September 8 – October 15, 2022

Mnuchin Gallery
45 East 78 Street
New York, NY 10075

Partners: Robert Mnuchin, Sukanya Rajaratnam, Michael McGinnis
Exhibitions Director: Kelly Jost Gardiner
Director of Operations: David McClelland
Senior Registrar: Arrow Mueller
Artist Liaison: Zoe Weinstein

Design: McCall Associates, New York
Printed by Meridian, Rhode Island

ISBN: 978-1-7341059-7-1